GREEN FIRST!

GINGKO PRESS

GREEN FIRST!

ISBN 978-1-58423-561-3

First Published in the United States of America by
Gingko Press by arrangement with
Sandu Publishing Co., Ltd.

Text edited by Gingko Press.

Gingko Press, Inc.
1321 Fifth Street
Berkeley, CA 94710 USA
Tel: (510) 898 1195
Fax: (510) 898 1196
Email: books@gingkopress.com
www.gingkopress.com

Copyright © 2014 by Sandu Publishing
First published in 2014 by Sandu Publishing

Sponsored by Design 360°
– Concept and Design Magazine

Edited and produced by
Sandu Publishing Co., Ltd.

Book design, concepts & art direction by
Sandu Publishing Co., Ltd.
Chief Editor: Wang Shaoqiang

Cover project by Kenichi Matsumoto

sandu.publishing@gmail.com
www.sandupublishing.com

All rights reserved. No part of this publication may be reproduced or transmitted in any form or by any means, electronic or mechanical, including photocopy, recording or any information storage and retrieval system, without prior permission in writing from the publisher.

Printed and bound in China

GREEN FIRST!

Earth Friendly Design

Designing for Sustainability
by Gemma Warriner

Traditionally defined as the color between blue and yellow, 'green' now seeks a more profound association within a world confound by the uncertainties of the future. Beyond its psychological connections with the natural environment and sustainability, 'green' manifests a new dialogue that asks for our reconsideration of what exactly green looks like.

As active 'makers,' designers are exposed as central contributors towards a utopian, sustainable vision of the future whereby the material actions, processes and solutions they generate seek the adoption of social and environmental responsibility. Beyond this act of conscious materialization, however, 'green' design exists more appropriately within the process of forward thinking, where sustainability is understood as a target, not an action. By itself, 'green' design cannot resolve the environmental issues which confront civilization, but it's a fundamental first step towards shifting behaviors, habits and the way we envision ourselves and the world around us.

A showcase of new perspectives, this book presents an eclectic compilation of awareness-raising designs arrived at through research-led, critical thinking design practices. The projects, sourced from an international collection of designers, present design as a form of global dialogue whereby ideas surrounding sustainability are visualized in order to speak to a universal

audience. Both designers and consumers are here exposed to such concepts, expressed across manifold disciplines including graphic, product, interior, fashion and industrial design, and are compelled to reconsider their role and responsibility in the pursuit of a sustainable future.

Since sustainability requires the participation of a widespread audience, we see this book as being bound by a single, mutual objective—designing for behavior. In this instance, design thinking is placed at the forefront of the design process, with a focus on how the communication of an idea may instigate behavioral change. Richard Buchanan, in his text 'Wicked Problems in Design Thinking,' explains that the power behind design thinking is about "turning to the modality of impossibility," and understanding that the impossible "may actually only be a limitation of imagination that can be overcome by better design thinking." These projects demonstrate that sustainable design does in fact exist beyond the material physicality of an object and rather look toward strategies that will engage humanity with ideas that will enlighten and instigate change.

In order to more visibly explain how the process of design thinking may give life to 'green' design, I refer to the project Twenty-Fifty: a visual data exploration of the global food crisis predicted for the year two thousand and fifty as a result of the inability of the earth's natural resources to meet future demand. Holding its own place within a book focal to sustainability, I had to question how exactly do we define 'green' design? I do believe the answer lies within a human centered approach to design, whereby the needs and motivations of people are placed at the centre of the design process. The 'green' nature of Twenty-Fifty is therefore embraced by the designer's empathetic

approach and perspective of the end-user as they seek to educate and challenge consumers about how the future may unfold.

The drive towards a transition into a sustainable future has never been more highly anticipated than it is today. This book acts as a reference point on rethinking how we think about design in the context of a world that seeks sustainable solutions in the face of uncertainty. Here, design presents itself as a powerful creative tool that, when utilized with consideration, has the power to shape our world and to guide our perception of it. Sustainability is a process, a lifestyle and an awareness about our place in relation the environment. Sustainability will exist with insight and will begin with an idea.

Gemma Warriner
Visual Communication Designer based in Sydney, Australia;
Interested in food design and information visualization;
Graduated in Visual Communication from the University of Technology, Sydney, 2013;
Working across digital and print based design including branding, packaging and photography.

1. R. Buchanan, 'Wicked Problems in Design Thinking,' 19

Client
NPO Echigo-Tsumari Satoyama Collaborative Organization

Work Type
Product

Design
Kenichi Matsumoto, Yoshihuko Masuyama

Tree Rain Wear

This raincoat was sold at the Echigo Tsumari Art Triennale held in Niigata, Japan, the theme of which was "Humans are part of nature." The aim of this design is to change the melancholy experience of rain into a positive one. The raincoat can be folded and packed into a leaf-shaped bag.

Photography
Kotaro Tanaka

Client
MOTTAINAI Campaign

Work Type
Product

Design Agency
GARBAGE BAG ART WORK (C) MAQ inc.

Arctic

This design aims to inspire caring for animals living in the Arctic.

Creative Direction
Yoshihiko Yamasaka

Design Agency
GARBAGE BAG ART WORK (C) MAQ inc.

Work Type
Product

Client
GARBAGE BAG ART WORK

Rabbit

This design aspires to turn trash bags into rabbits; when the long plastic handles are tied together, they become the rabbits' ears. The rabbits are an adorable reminder to take your trash home with you.

Client — Oy
Work Type — Product
Design Agency — Ryohei Yoshiyuki to Job

A Cup of Coffee

A man, a break, a cup of coffee, a cigarette — even that short break might be the best moment of your day. "A Cup of Coffee" is an ashtray made from used coffee beans, inspired by the habit of using old coffee grounds as an ashtray.

Creative Direction
Ryohei Yoshiyuki

Client
ECO JAPAN CUP

Work Type
Promotion

Design Agency
SAKURA Inc.

Plastic Shopping Bags

Plastic bags are unnecessary, and their production generates carbon dioxide. This project reminds us that we can help save more power by not using plastic bags.

Photography
Norio Kitagawa
Illustration
Yuzo Isoda

85.4g

この数字はレジ袋一枚の生産・焼却に発生する二酸化炭素排出量です。

持ちたくないレジ袋。

REJI BUKURO
IMAGE DOWN
PROJECT
レジぶくろイメージダウンプロジェクト

レジ袋の削減と、それに伴うCO2の排出問題をデザインはどこまで解決できるのだろう。いや、もしかしたら問題の本質に近づけるのは、「持ちたくない」レジ袋をデザインする事かもしれない。

一見、数字が印字されているだけのレジ袋。しかし、この数字はレジ袋が生産・焼却される際に発生するCO2の排出量である。

CO2の排出量を表記することで、レジ袋の利用が地球温暖化に直結することを伝える。このレジ袋を持って街を歩けば、だれでも一瞬にして悪役になれる。

このような思いでデザインした持ちたくないレジ袋。

ぜひ、全国のスーパーやコンビニでこの利用いただき、あまり補充されることのないレジ袋として生活者の皆さまの近くに置いてください。もしレジ袋を使わなければいけない時は、地球に向かってこう一つぶやいてください。「地球の資源をいただきます」と。

レジ袋も食物も、同じ地球からの恵み。

Client: Louis Vuitton Japan
Work Type: Branding
Design Agency: N.G. Inc.

Louis Vuitton Forest Box

A special box for an exhibition, consisting of "seeing" (photography book), "listening" (CD), "touching" (wood chips), and "smelling" (aroma mist).

ST WOOD

SUGI | HINOKI | SHIRAKABA
BUNA | TOCHI | KUSU
KURUMI | KEYAKI | KARAMATSU

texture of the wood and let your imagination take you on a journey through the forest.

MIKIYA TAKIMOTO PHOTOGRAPHS

RYUICHI SAKAMOTO MUSIC

music of the forest composed by Ryuichi Sakamoto

FOREST AROMA

HINOKI | AKAEZOMATSU | MOMI

Enjoy the scent of the forest with oils extracted from a variety of trees.

Client	Work Type	Design Agency
---	Product	MATTEO CIBIC STUDIO

Domsai

Designed by hand and produced with love in Nove (ITA). Each domsai has its own personality, just as each cactus has its own dome, tailor-made and hand-blown, that differentiates it from the others. Produced by Bosa Ceramiche.

Client
Self-initiated

Work Type
Product

Design
Stokke Austad, Andreas Engesvik

The Woods

The inspiration for this project came from the forests and lights of the North. The fascinating process of trees changing colors and transparency through the seasons was captured in this free-standing glass sculpture, appropriately titled "The Woods." Each hand-made sculpture consists of seven trees joined in two separate sections.

Client
MOTTAINAI Campaign

Work Type
Branding

Production
The Mainichi Newspapers/ITOCHU

MOTTAINAI

The MOTTAINAI Campaign was set into motion by Nobel Peace Prize winner Prof. Wangari Maathai. The concept is the "3R+R": to Reduce waste, Reuse finite resources, Recycle what we can and Respect everything, including the Earth.

MOTTAINAI

MOTTAINAI is the painful longing for things that have been lost.

MOTTAINAI

MOTTAINAI is a way to say thanks to someone who has helped you.

MOTTAINAI

It is a message from Japan to the world.

MOTTAINAI

MOTTAINAI is a small kindness that sometimes loses out to "MENDOKUSAI".

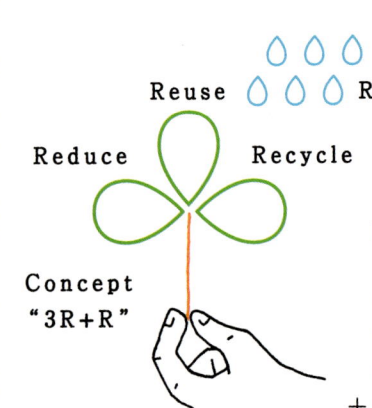

Reuse Respect
Reduce Recycle
Concept "3R+R"

MOTTAINAI

Reduce : Produce less waste.
Reuse : Use things over and over for a long time.
Recycle : Spread things around so they can be used repeatedly.
+ Respect : Respect people who value the MOTTAINAI concept.

MOTTAINAI
モッタイナイは、世界中のアイコトバ。

MOTTAINAI
It is a message from Japan to the world.

Client	Work Type	Design Agency
Ichibanya	Product	nendo Inc.

Forest-spoon

Spoons are a tool for eating, and the world is full of spoons designed for that function. This design makes spoons fun to look at while they aren't in use. The spoons resemble single trees when lying alone on the shelf, but the design gains new charm when multiple spoons are brought together, creating a forest in the home.

Photography
nendo Inc

Client	Work Type	Design Agency
mathery.it	Product	Mathery

Scolapianta

Multidisciplinary studio Mathery designed "Scolapianta," a dish rack that has been remodeled to water your plants while drying the dishes.

Client	Work Type	Design Agency
Self-initiated	Product	XD Design

Herba Herb Garden

Herba is a potted herb garden made of bamboo fiber which lets you grow your own chives, parsley and basil. Now your fresh herbs can be gathered from inside your own home.

Client
I'mperfect x Ornapaper

Work Type
Branding

Design
Quekish & Cheong Zhi Ying

I'mperfect x Ornapaper

Every year about 285,000kg of carton materials in Ornapaper are discarded due to minor blemishes like paper marks and bend lines. These rejects are eventually shredded and contributed to a joint effort with I'mperfect. Ornapaper has given these rejected materials a more meaningful incarnation as household pieces that make our daily lives easier, such as folding chairs, expandable side tables, and desktop organizers, to name a few. There are also objects of desire, witty items, and designer pieces, such as a shopping bag that transforms into a table lamp.

Client: Self-initiated
Work Type: Product
Design Agency: ZEUP Design Studio

PooLeaf Pen

PooLeaf Pen is designed to look like a blade of grass when it isn't in use. The design gains new charm when multiple pens are brought together.

37

Client
Self-initiated

Work Type
Product

Design
Heewon Jeong, Sangwoo Nam

Sticky Leaf Ivy

Bored with ordinary sticky notes stuck all over your desk? Take a leaf from the tree. These leaf-shaped sticky notes are a fabulous way to grow your own tree.

Photography
Heewon Jeong, Muncheol Kim

Draw your dream message !

Client	Work Type	Design
Self-initiated	Product	Heewon Jeong, Sangwoo Nam

Sticky Leaf Deco Birch

Sticky Leaf Deco is a new decoration collection made to refresh monotonous routines. It goes beyond the simple function of a note pad to add a touch of nature to your desk. Important notes can be kept on Sticky Leaf by attaching it to the branch-shaped memo pad.

Photography
Heewon Jeong, Muncheol Kim

9 05

Client
Ornapaper

Work Type
Branding

Design
Raymond Lai, Cheong Zhi Ying, Joseph Foo

Ornapaper Calendar 2013

The 2013 Ornapaper Calendar is a summation of the company's new direction. In order to attract more young talent, Ornapaper is rebranding themselves as an innovative and environmentally accountable company. The multi-use calendar uses core materials from their business, and is part of several communication steps the company is taking to promote their new brand.

Orna paper 2013

ORNAPAPER

Ornapaper Berhad is one of Malaysia's leading supplier of corrugated paper products and packaging. Incorporated on 24 July 1990, the company is founded on our commitment to quality, best practices and innovation. We are on track to becoming the industry leader in environmentally-friendly packaging.

In these enlightened times, packaging is often viewed as a necessary evil. We believe it is our mission to help mitigate the environmental impact of business and industry by providing our customers with responsibly manufactured packaging products that fulfill both brand and technical requirements from cradle to grave.

We achieve this by working closely with customers to address their unique quality, cost and environmental issues. We strive to ensure that our operations and our products meet international environmental standards. We recruit and nurture the best talents to ensure a vibrant, customer oriented organisation.

Whether it is our R&D, engineering, logistics or marketing team, we are united in our commitment to developing effective and innovative solutions for our clients. We are also engaged in designing and producing storage solutions and furnishing made out paper, which are an environmentally-friendly alternative to plastic.

Looking ahead to the future, Ornapaper will continue to improve our responsiveness and efficiency by further strengthening our infrastructure, technological capabilities and environmental standards. We will complement these by continuing to enhance our human resource policies and practices.

Our ultimate goal is to benefit both our customers and our organisation while fulfilling our obligations to our planet.

Client
Archicake

Work Type
Branding

Design
Zhan Bokai

Archi-Green

Archi-Green exhibition is a dialogue between green-colored buildings and green (energy efficient) buildings. Exhibition identity is expressed using the rational lines found in architecture and the motifs of green leaves.

[ARCHI-GREEN]

綠色建築與綠建築的對話

PART1

Client Work Type Design
Neo Green Product Tomohiro Kato

Leaf Letter

In ancient Japan, people used leaves as a tool to exchange their messages, which is the origin of hagaki – the Japanese postcard. "Leaf Letter" takes this idea of writing on leaves and brings it into modern times. With the spread of personal computers and mobile phones, we are beginning to seem further away from nature. Can sending a message on a leaf reduce the distance between nature and people by reviving the hand-written letter?

Client
Self-initiated

Work Type
Product

Design
Qiyun Deng

- Graft
-

Graft is a series of disposable tableware made of bioplastic PLA that reveals the source of its materials – the plants. In nature, texture and form exist with functions that can be utilized for other purposes. For example, a celery stem serves as the handle of a fork; the petal of an artichoke becomes the bowl of a spoon. By provoking both visual and haptic sensations, "Graft" raises a question: will you throw them away easily?

Client
Teraoka Organic Farm

Work Type
Branding

Design
HIGUCHI Kentaro

Teraoka Organic Farm

To help the consumer instinctively understand that the products are organic, the designer created a signature design of hand-drawn vertical stripes that distinguish these from other products. The abstract design is intended to look like soil or even thick foliage depending on how it is viewed. The aim was to evoke its organic nature while retaining diversity. The carefully hand-drawn images express the farm's sincere stance towards agriculture.

寺岡有機農場
Teraoka Organic Farm

有機ベビーリーフ
Organic Baby Leaf

寺岡有機農場
Teraoka Organic Farm

有機サラダ
ほうれん草
Organic Salad Spinach

寺岡有機農場
Teraoka Organic Farm

有機
にんじん
Organic Carrot

Client
Chamber of Commerce and Industry of Okawa city, Fukuoka

Work Type
Product

Design Agency
Tetusin Design Office

Okawa-conserve

This design is intended to inspire a new lifestyle with its fusion of "Eat" and "Tree" – "moku-mogu" means "tree-munch" in Japanese. As more and more people gather around the table, the single trees become woods, and the woods grow into a forest.

57

Client	Work Type	Design
MORINOIE	Branding	Motoki Koitabashi

Rice Package of MORINOIE

Two versions of packaging for MORINOIE organic rice. The white package is for polished rice. The brown package is for unpolished rice.

Illustration
Yoko Hino

さわのはな

玄米

山形県産
農薬化学肥料不使用

Client
MORINOIE

Work Type
Branding

Design
Motoki Koitabashi

Traditional Vegetables Pamphlet of MORINOIE

A pamphlet showing the traditional vegetables cultivated in Mamurogawa with MORINOIE.

Illustration
Yoko Hino

森の家
取扱品目一覧

伝承野菜

甚五右ヱ門芋
勘次郎胡瓜
弥四郎ささぎ
肘折大根
角川かぶ
最上かぶ
西又かぶ
赤根ほうれんそう
最上赤
黒五葉
青ばこ豆
青黒豆
雁食い
もってのほか
からどり芋
畑なす
神代豆
さわのはな
雪菜
雪割り菜
おかひじき
凍み大根

山菜・きのこ

あさつき
山うるい
はりぎり
山にんじんの葉

最上の食材

とうきび
おくら
笹まき
卵
栗
果物
しそ巻

Client
Self-initiated

Work Type
Promotion

Design
Wataru Yoshida

Composition of Mammals

These posters are promotional material for a conceptual exhibition called "Composition of Mammals," set in the fictional Museum of Biological Science. The exhibition would study the anatomy of mammals with displays of taxidermy and skulls. The designer's intention was to use the promotional posters to bring attention to the complex and interesting structures of the bodies of mammals.

Client
Daebeté

Work Type
Branding

Design Agency
Victor Design

Daebeté

Packaging inspired by the endangered animals of Taiwan. The design conveys a message of animal conservation.

daebete

自 然 栽 植 ． 自 然 喝 好 茶 。

Naturally planted for fine natural tea
Natural agriculture for primitive flavor
Savor tea each day! Respect natural environment with a simple life philosophy

Endangered Species in Taiwan

The distinctive high mountain climate brings good tea.

Client
Self-initiated

Work Type
Poster Design

Design
Latysheva Ksenia

- Their Life is
Not a Game
-

Their Life is Not a Game was created to raise awareness of animal extinction. Many species in Russia are on the verge of extinction, and while modern society has no need to kill animals to survive, the "bloody game" of hunting is still considered to be entertainment by many people. The luxury of fur apparel is also something that many people could do without, especially when the price of this luxury is an animal's life.

GAME OVER

THEIR LIFE IS
NOT A GAME

GAME	OVER
LIFE	50

THEIR LIFE IS
NOT A GAME

GAME	OVER
LIFE	250

THEIR LIFE IS
NOT A GAME

GAME	OVER
LIFE	5000

THEIR LIFE IS
NOT A GAME

Client
CAEM

Work Type
Print

Design Agency
Insignia Creativa

- Murica
Ecological
Agriculture
-

This informative brochure is about the processes and benefits of ecological agriculture, and represents the main manufacturers in the region. It tries to respect the same environmental values of the customer, and utilizes recycled paper and a foldable, standard size so only one type of ink had to be applied on each side.

Photography
La Industrial
(Jose David Sanchez Asensio)

AGRICULTURA ECOLÓGICA
Región de Murcia

Listado de operadores

10
BUENAS RAZONES PARA CONSUMIR ALIMENTOS ECOLÓGICOS.

1. Protegen nuestra salud.
2. No han sido manipulados ni química ni genéticamente.
3. Incrementan la biodiversidad.
4. Ayudan a preservar el entorno.
5. Reducen el uso de energía.
6. Fomentan la calidad no la cantidad.
7. Evitan excedentes.
8. Contribuyen a la creación de empleo.
9. Garantizan un precio justo para el agricultor.
10. Recuperan sabores y aromas perdidos.

Client: Greeners Action
Work Type: Promotion
Design Agency: Alonglongtime

Mobile Community Recycling Shop

EPD is co-operating with Greeners Action (an environmental protection organization) to hold a promotional programme – MCRS. MCRS conducted promotional and educational activities, as well as recyclables collection, at designated times and locations for approximately one year. MCRS reached out to engage the public with face-to-face promotion, and served as mobile recycling points in order to convey messages about solid waste recycling in Hong Kong to the public.

71

Client	Work Type	Design Agency
---	Poster Design	VOYRD

- Hong Kong Cleanup Campaign

This project attracts both parents and their children by connecting to the feelings and memories both generations have about superheroes. The slogan is "Be your own Hero, Super clean Hero!"

Client
Earthman

Work Type
Promotion

Design Agency
Reformer Design Studio

- Alive
-

Each step, each movement, each action in our daily life affects the people around us, and the world itself. You and I are linked by the need to protect the environment. So, ACT NOW!

75

Client	Work Type	Design
Self-initiated	Product	Smilte Bagdziune, Elvita Brazdylyte

Natural Handmade Lollipops

Lollipops studio TUTU presents Natural Handmade Lollipops, because people fall in love with the TUTU lollipops at first sight. Made from natural ingredients, these "good mood chargers on a stick" are never identical and their flavors make even the greatest skeptics smile.

Photography
Paulius Gasiunas, Visvaldas Morkevicius

77

Client
Vinyl Environmental Council

Work Type
Promotion

Design
Akijiro Kumagaya

- PVC Innovation Design Contest 2011

-

This poster was designed for a competition in which applicants were required to use PVC. Fake food (specifically Japanese fake food samples) and plastic wrap are typically made of PVC, so the purpose of this poster was to ask applicants "How do you cook (design) PVC?"

Photography
Akijiro Kumagaya

塩ビものづくりコンテスト2011
PVC Innovation Design Contest 2011

PVCくぼ塩化ビニルンは、柔らかさが自由にできる、透明感がある、発色が良いなどの特徴と共に、耐久性・リサイクル性、加工性に優れている機能素材です。

また近年、世の中のPVCに対する意識が地球環境にやさしい資源系、環境負荷の低減などの特長や科学的な正しい理解により、以前より再評価されています。PVCの特色を生かした新たな可能性をひらく製品を商品化することは、日本国内のものづくりの優位性を力強くし、中小企業のものづくりを振興することになるでしょう。

「塩ビものづくりコンテスト」では、軟質塩ビの特長などを生かし、独創性・新奇性等に優れた作品を募集し、その中から将来の可能性を広げるような優れた作品を選定し、表彰します。一次審査を通過した優れた作品候補は協力会社がプロトタイプを制作し、製品化の応募作品とともに評価されます。

テーマ：「新たに切り拓く、PVCの可能性」
身近な生活で出会うPVCとの出会いから新しい用途を取り込む作品・製品を提案下さい。

作品募集：国内外未発表の軟質塩ビ素材を使用した作品
製品応募：国内に流通している既存の軟質塩ビ製品や中間加工材料及び試作品

| 作品提出 | 2010.10.20 - 2011.2.28 | 製品エントリー | 2010.10.20 - 2011.2.28 |
| | | 製品提出 | - 2011.5.20 |

日本ビニル工業会 www.vinyl-ass.gr.jp

Client
Aguas de Fuensanta

Work Type
Branding

Design
Pati Nunez

FUENSANTA

Fuensanta's origin is linked to nature; the designers of this project aimed to remind consumers of this by imitating Mother Nature. Fuensanta's glass bottles have been re-designed to appear as if they had been left in a forest and overgrown by wild plants.

Client
Self-initiated

Work Type
Product

Design
Norihiko Terayama

"g,a,r,d,e,n" 2012

This 30-cm ruler is inspired by flowers blooming in a garden.

Client
Stalzer Lutz Gärten

Work Type
Branding

Design Agency
moodley brand identity

Verdarium –
Corporate Identity

An Austrian environmental planning office fulfilled its dream by opening "the Verdarium" in a small town near Vienna. The green oasis (3000 square meters) is both an experimental garden and a sales location for completely weather-resistant furniture. Clients are able to visit and experience the atmosphere, materials and spacial reference of the furniture and the garden for themselves.

STALZER LUTZ
Verdarium

RAUM FÜR GÄRTEN

presented by *verdarium*

Client
The Institute of Critical Zoologists

Work Type
Print

Design
Zhao Renhui

A Guide to the Flora and Fauna of the World

The guide seeks to document and reflect on the myriad of ways in which human action and intervention are slowly altering the natural world. The guide presents a catalogue of curious creatures and life-forms that have evolved in often unexpected ways to cope with the stresses and pressures of a changed world. Other organisms documented in the installation are the results of human intervention, such as mutations engineered to serve various interests and purposes ranging from scientific research to the desire for ornamentation. The project was also presented as an installation of a modern day cabinet of curiosities during the Singapore Biennale 2013.

Client
Restaurant Mistral

Work Type
Branding

Design Agency
DRY Creative

•
Mistral
•

Mistral is the first Swedish restaurant to be entirely dedicated to organic gastronomy. The graphic profile produced by DRY reflects Mistral's culinary philosophy and unblinking focus on natural flavours.

Photography
Mikael Strinnhed

MISTRAL

Client
Self-initiated

Work Type
Promotion

Design
Gianpaolo Tucci

PANTONE – NATURE

What would swatches of nature look like? This is the question that bothered me while I explored different natural surfaces in Tokyo, and inspired me to envision a possible Pantone series in which the colors of nature take shape and become flat digital representations of the physical world.

PANTONE®
65 THATCH

PANTONE®
3C CLOVERS

PANTONE®
13 STONE

Client	Work Type	Design	Photography
---	Product	Tsuyoshi Hayashi	Tsuyoshi Hayashi

-
Kawara Bench
-

Kawara Bench is designed to salvage industrially rejected Japanese roof tiles that would otherwise be discarded. 5% of the whole production (more than 65,000 pieces per year) end up disposed in landfills or smashed and used in road construction. These tiles are thrown away because of tiny flaws even though they still have unique values, such as their color, texture, and durability, as well as a smooth curve that invites people to sit on them. By cutting off the damaged part and mounting the tile on a wooden structure, the "useless waste" can be turned into "useful matter" once again.

Client
Bentu Design

Work Type
Product

Design Agency
Bentu Design

- 点 dian
-

This design used recycled rebar and cement as materials, calling people to return to the basics.

Photography
Sing Chan

Other Credits
Peng Zeng, Sing Chan

Client
Bentu Design

Work Type
Product

Design
Bentu Design

- U
-

This design used recycled rebar and cement as materials, calling people to return to the basics.

Photography
Sing Chan
Other Credits
Peng Zeng, Sing Chan

Client
Bentu Design

Work Type
Product Design

Design
Bentu Design

-
TU
-

Cement is gray, the simplest color. It is so simple that the whole world is unaware of being surrounded by it, so complex that its chaotic beauty can only be realized by mixing all the colors on the palette.

Photography
Sing Chan
Other Credits
Peng Zeng, Sing Chan

Client
Self-initiated

Work Type
Product

Design
Meirav Barzilay

-
Photosynthesis Lamp
-

A lamp made of a metal grid with a vine at its base, bringing light and nature into your home. Choose the type of vine and let it create a natural lamp shade as it grows. It is necessary to use an energy saving light bulb, which will not only help your plant grow, but will also provide eco-friendly light.

Photography
Meirav Barzilay

Client
Self-initiated

Work Type
Product

Design
Miroslava Djordjevic & Ksenija Josifovic

- **Re: Light**
-

The purpose of this lamp is focused on providing an aesthetically pleasing, comfortable, multifunctional piece of furniture, as well as to introduce a visual interpretation of natural forms into the home. The piece can give a small beam of narrowly-focused light when it's brought close to the table-like wooden surface, or provide wider ambient light when put up to its highest position. Visually it is intended to resemble a tree, the most common and distinct form in nature. The lamp is designed to bring nature back into people's everyday habitats.

MEDITATION TREE SUN READING TIME TEA-COFFE TIME SUSTAINABILITY

100 50

170

101

Client	Work Type	Design	Photography
Bentu Design	Product	Bentu Design	Sing Chan

- 力 li
-

When an unruly sprout breaks through concrete, is it because of its strength or its pliability? This project captures the irrepressible growth of plants and increases appreciation for their extraordinary abilities with a planter that appears both familiar and unusual to everyone who encounters it.

103

Client	Work Type	Design
Self-initiated	Print	Gemma Warriner

Twenty-Fifty

Twenty-Fifty is a visual exploration of the global food crisis predicted for the year two-thousand and fifty – a result of the inability of the earth's natural resources to meet future demand. The project presents a series of eight data visualizations, each exposing one primary issue responsible for this future crisis. It looks closely at population growth, urbanization, food production, food waste, genetic modification, climate change, consumption trends, and agro-biodiversity as the main influential factors. This project was mentored by Kate Sweetapple.

105

Client
Toshiyuki Hirano and danny

Work Type
Promotion

Design Agency
UMA / design farm

- Toshiyuki Hirano and danny Oyama Exhibition
-

This is an exhibition flyer for two illustrators, Toshiyuki Hirano and danny. 'Oyama' means "mountain" in Japanese. The square paper is designed to fold diagonally, so its shape resembles a mountain. On both sides are mountain illustrations drawn by the two illustrators.

Photography
Yoshiro Masuda

107

Client	Work Type	Design
Self-initiated	Product	yuruliku Design

Green Marker

Let greens crawl onto your desk and shelves with these grass-like bookmarkers, which attach to the tops of your favorite pages.

Client
h-concept

Work Type
Product

Design
Toshihiro Aya

Ha Uchiwa

It was on a hot summer day when the idea of a leaf-like fan was conceived. Ha Uchiwa was designed to inspire people to consider how people lived in the summer in the past, and to enjoy ecological life today with smile.

Photography
Toshihiro Aya

111

Client
Dcell

Work Type
Product

Design
Kahn Jung

- ## Jungle
-

Decorate your bookcase with wilderness scenery and displays of all kinds of animals.

113

Client
Gruner + Jahr AG & Co KG, GEO Magazine

Work Type
Product

Design
Kolle Rebbe GmbH

Meltdown

Meltdown – the first board game that melts. The aim of the game is to take a polar bear family from the permanent ice floes to safety on the mainland. It's a race against time, as the way leads across real, slowly melting ice floes, which children can make themselves with the accompanying mould, a bit of water and a freezer compartment. The chunks of ice are arranged on a blue polar sea sponge to form a small Arctic. The sponge serves as a game board as well as a way to absorb the melting ice.

115

Client
GARBAGE BAG ART WORK

Work Type
Product

Design Agency
GARBAGE BAG ART WORK (C) MAQ inc.

Fuji Mountain

One white garbage bag and nine blue garbage bags are arranged in a way that transforms them into Mount Fuji.

Creative Direction
Yoshihiko Yamasaka

GARBAGE BAG ART WORK
ゴミ置き場をアートにするプロジェクト
gba-project.com

このゴミ袋の売上金の一部で、
富士山清掃活動団体を支援しています。

青9枚＋白1枚＝10枚入り

Mt.FUJI
GARBAGE BAG
ゴミ置き場を富士山にしよう

Client: WWF
Work Type: Promotion
Design: Dora Pete

WWF Campaign for Animals Close to Extinction

This conceptual project was designed as an advertising campaign for WWF for Nature. It seeks to bring attention to the importance of saving rare animals before they are totally extinct.

NORTHERN REINDEER *(Rangifer tarandus)* in 2024

for a living planet® WWF

POLAR FOX *(Alopex logopus)* in 2036

for a living planet® WWF

Client
WWF

Work Type
Poster

Design
Dan Heron

- Trees
-

This is a personal project that combines nature with infographics. The initial idea was branding for a fictional museum of trees, which eventually became the inspiration for an exhibition titled "Extremes of Trees" and the information graphics for the exhibition.

WIDEST

The Sunland 'Big Baobab' is in Modjadjiskloof in Limpopo Province, South Africa and is famous internationally for being the widest of its species in the world. Africa is symbolised by these magnificent trees. The Sunland Big Baobab is carbon dated to be around 6000 years old.

BIG BAOBAB FACTS:

22 metres high
47 metres in circumference
Home to many bird species
The hollow inside of the tree contains a fully functioning pub and wine cellar!
There have been fires in the hollow in 1650 AD, 1750–1780, 1900, 1955 and 1990

22 M

47 M

10.64 M

EXTREMES

TREES

COAST REDWOODS

TALLEST

Hyperion is the name of a Coast Redwood, in Northern California that was measured at 115.61 metres (379.3 ft), which ranks it as the world's tallest known living tree.

LARGEST

Lost Monarch is the name of a Coast Redwood (Sequoia sempervirens) tree in Northern California that is 26 feet (7.9 m) in diameter at breast height, and 320 feet (98 m) in height. The tree is estimated to contain 34,914 cubic feet (1,200 m3) of wood volume, making it the largest coast redwood in terms of overall wood volume (the Del Norte Titan is listed as the largest single-stem coast redwood tree, in part because the basal measurements of the Lost Monarch contain multiple stems).

COAST REDWOOD FACTS

They are evergreen trees
They live from 1200 to 1800 years
There are 41 measured living trees more than 360 feet (110 m) tall
A coast redwood claimed to be 424.08 feet (129.26 m) was felled in November 1886

115.61 M

EXTREMES
TREES

OLDEST

The Llangernyw Yew is an ancient yew (Taxus baccata) in the churchyard of the village of Llangernyw in Conwy County Borough, North Wales. The tree is fragmented and its core part has been lost, leaving several enormous offshoots. The girth of the tree at the ground level is 10.75 m.

Although it is very hard to tell the age of Yew trees, it is believed to be aged between 4,000 years and 5,000 years old, making it the second or third oldest individual (non-clonal colony) living organism in the world.

4000+ YEARS

10.75 M

EXTREMES
TREES

EXTR
EMES

RECORD BREAKING TREES FROM AROUND THE WORLD

JULY 15th - AUGUST 25th

Liverpool Road
Castlefield
Manchester
M3 4FP

0161 442 3399

www.mmot.org

TREES

121

Client
Self-initiated

Work Type
Branding

Design
Cecilia Hedin

- Into the Wilderness
-

Inspired by nature and the animals that inhabit it, this book is covered in an embossed pine tree pattern.

Client
Crossroads Trading Co.

Work Type
Branding

Design
Pei Liew

Crossroads Trading Co. Rebrand

This is a hypothetical rebrand for Crossroads Trading Company, a recycled fashion brand. Using all recycled and repurposed materials, the design spotlights the beauty of distress. This is meant to reflect the ideology that second-hand clothing can be much more interesting and beautiful than new clothes.

CROSSROADS TRADING CO.

Client
Academy of Art University

Work Type
Branding

Design
Jiajie (Roger) Wang Project

American Apparel Sustainable Shoe Pack

The mission of this project was to create a sustainable line of shoe packaging for a specific fashion brand. In order to reflect the concept of "being green," all the materials used for this project were required to be environmentally-friendly. The deliverables are four items which include the shoe packaging itself, an invitation letter, a gift card, and a DVD or a flash drive.

129

Client
The Berlin Paper Company

Work Type
Promotion

Design
Laura J. Merriman

- The Berlin Paper Company Paper Promotion

-

The Berlin Paper Company is a fictional business based in Berlin, Germany. Their paper promotion focuses on a specific line of high-quality, environmentally friendly products. Paper samples are designed to give the impression that the bark of an actual tree is inside a wooden box. On the back of each sample are facts and scientific illustrations about each tree species as well as information about the sheet of paper itself.

Client
Nando's Peri Deli

Work Type
Branding

Design
Justin Joshua, Jono Garret

- Chalk Stencils
-

Nando's Peri Deli is an organic food restaurant that believes that all of its packing should be 100% recyclable. We created a poster series that promoted this philosophy in the way it was created, designed and articulated through headlines that conveyed the same message.

Writing
Suhana Gordon

133

Client
Arboledas Palmira

Work Type
Branding

Design
Diego Leyva

-
AP
-

Arboledas Palmira (AP) strives for balance between nature and design. AP is a proposal created to confirm the possibility of living in tune with nature. Organic materials, design, and natural elements were used to keep the project's carbon footprint to a minimum. Ecological materials are used not only for printing substrates, but also for the houses' construction.

Client
Tuffy

Work Type
Branding

Design Agency
Saatchi & Saatchi (CT)

-
Tuffy Garbage Bag
-

Tuffy brands is a Cape Town based company specializing in manufacturing refuse bags. Made from 100% recycled materials, with a high level of post-consumer waste, they are effectively turning trash into trash bags.

Illustration
Justin Southey

Client
FH Aachen/
University of Applied Sciences

Work Type
Print

Design
Stefan Zimmermann

Photography
Stefan Zimmermann

- Plastik Ahoi!
-

According to estimates by the United Nations Environment Programme (UNEP), more than 6.4 million tons of plastic waste reaches the oceans every year. The ocean currents carry the trash to five large patches, far away from civilization or governmental responsibilities. The greatest of these patches is "The Great Pacific Garbage Patch" in the North Pacific. These information graphics examine the causes, distribution, effects and dangers of plastic waste in the oceans.

15 %
15 Prozents des Plastikmülls in den Meeren erreicht die Küsten und Strände

15 %
15 Prozents des Plastikmülls in den Meeren treibt an der Meeresoberfläche.

70 %
70 Prozent des Plastikmülls in den Meeren sinkt zum Meeresgrund.

Forscher gehen davon aus, das sich dort große Mengen von schweren Plastiksorten, wie z. B. PET, oder HDPE befinden.

- Treibt an der Meeresoberfläche
- Sinkt zum Meeresgrund

1 %

2 %

5 %

61 %

31 %

- Medizinische und persönliche Hygiene
- Müllentsorgung
- Meer- und Binnenverkehr
- Konsum von Tabakprodukten
- Küsten- und Freizeitaktivitäten

Client
Th-ink Toners Corp

Work Type
Branding

Design Agency
Diego Leyva

TH-INK

The goal was to create a fun, juvenile and contemporary brand for an ink & toner company located in Mexico City. The design combined an eco-friendly style with eccentric yet elegant visual forms, creating a balance between fluid objects and bright colors found in nature.

Photography
Isabel Martinez

Client

Work Type
Print

Design
Joe Scorsone, Mirim Seo

Tomorrow

Tomorrow is a clock book about landfills in the U.S. Twelve different types of waste are represented, with each page showing information about different categories of landfills. The numbers represent either the decomposition time of materials or the amount of waste.

Photography
Mirim Seo

· MILK CARTONS ·

5 It takes five years for a cardboard milk carton to decompose in a landfill.

The average American consumes hundreds of gallons of milk and generates over 17 billion milk cartons each year. However, less than 1% of the 408,000 tons of milk cartons produced in 2006 were recycled; nearly either 99% ended up in landfills. It seems like the difficulty of recycling them is due to the fact that they are coated with wax and many states do not offer curbside pickup for recycling of waste cartons. That means over half a million tons of carton waste end up in landfills every year. It is estimated that the milk cartons occupied 1.3 million cubic yards of landfill space, or 0.1% of landfills by volume.

· DISPOSABLE DIAPERS ·

6 One child uses approximately six thousand disposable diapers by the age of 24 months.

In the United States, over 18 billion disposable diapers are thrown away every year. It is estimated that due to disposable diapers, over five million tons of untreated waste, and two billion tons of feces, urine, plastic, and paper are added to landfills around the world annually. It is said that disposable diapers are responsible for a significant share, about 5 to 10% of all household waste in Western countries. Just the diapers manufactured for American babies each year require 80,000 pounds of plastic, and over 200,000 trees. The untreated waste is a potential hazard for polluting ground water.

Client	Work Type	Design Agency
Rure Co.	Product	Meb Rure Design Studio

Recycled Silk Chair

Recycled Silk furniture series was designed with the idea of using recycled silk yarn as upholstery. This ecological and handcrafted furniture family consists of a chair, an ottoman and a stool, all of which are made of American white oak and recycled silk ribbons from Nepal. These recycled ribbons are obtained from leftover sari, the traditional cloth of Indian and Nepalese women.

145

146

Client	Work Type	Design Agency
KaCaMa	Product	KaCaMa Design Lab

PP Capsule

PP plastic caps are reborn as flexible beanbag chairs for living rooms. One PP Capsule up-cycles 4,000 plastic caps, using the excellent craftsmanship of local seamstresses to wrap them in eco-friendly fabric and turn them into furniture in a way that demonstrates care and love for the community as well as the environment.

Client
LE NATURISTE

Work Type
Branding

Design Agency
Paprika

LE NATURISTE

Based on healthy products, Paprika completely rebranded Le Naturiste's identity program to make their image more dynamic through every aspect, including their logo, packaging, corporate prints, and more.

NATURISTE S'ENGAGE
À CHANGER LA PERCEPTION
QU'ONT LES CONSOMMATEURS
DE LEUR SANTÉ, L'IMPORTANCE
QU'ILS LUI ACCORDENT ET
LEUR DONNER LES MOYENS
DE L'ENTRETENIR, POUR LES
AMENER À PROFITER
PLEINEMENT DE LA VIE.

naturiste.ca

Client Work Type Design Agency
Adidas Illustration Studio Intraligi

ADIDAS ORIGINALS

This collection consists of sustainable shoes and apparel made of eco-friendly materials.

Client

Work Type
Illustration

Design
MaMe Creative Beans, Maykol Medina (MaMe)

- Matsusanubar -

Matsusanubar is part of the series of tree typography I have been working on for the past several years. The theme of this piece is the pine tree. "Matsu" means "pine tree" in Japanese and "sand bar" in Arabic. Characters from both languages are used to represent the pine tree's growth in nature, and to make the theme understandable even for those who can't read it.

松樹千年翠

しょうじせんねんのみどり

真理が不変であるように、変わらないものの大切な価値を見失わないようにふと立ち止まってみてはいかがでしょうか。

155

Client
Self-initiated

Work Type
Poster Design

Design Agency
Shinmura Design Office

Forest

These designs represent some of the functions of forests on the earth. Forests are the lungs of the earth, and protect it by changing carbon dioxide into oxygen. They also serve as the "drugstores" of the earth. Life thrives on earth because forests exist. The earth will no longer be functional if carbon dioxide continues to increase.

The forest is
a hospital of the earth.
森は、地球の病院です。

The forest is
lungs of the earth.
森は、地球の呼吸器です。

Client
MUJI

Work Type
Poster Design

Design
Shinmura Design Office

MUJI
Summer Sales

This poster was designed for MUJI Summer Sale. The use of leaves triggers people's memories of summer.

夏の思い出を詰めるための
無印良品。

Client
Niigata Prefecture

Work Type
Promotion

Design Agency
Shinmura Design Office

- Nurturing the 21st CenTREE
-

Nowadays we seem to have acquired easier lives but lost things of greater importance, such as beautiful scenery, clean air, and caring hearts. The "100 Years of Greenery in Niigata Prefecture" campaign intends to fix this by planting and nurturing trees for the next 100 years. This project will benefit people today, and will also be a wonderful legacy of greenery for the next generation to enjoy.

21世木を育てます。

まもなく終わろうとしている20世紀。振り返れば、私たちは、豊かな生活を手に入れた代わりに、地球を傷つけ、多くの自然を失ってしまいました。
今、私たちは、人間の生存の基盤である自然、とりわけ清らかな空気、美しい風景など、様々な恵みをもたらしてくれる緑を取り返すべきではないでしょうか。
そのため、新潟県民は、21世紀百年をかけて県民ひとりひとりの手で木を植え、育て、22世紀の人々に「緑の遺産」を残す
「にいがた「緑」の百年物語―木を植える県民運動」に取り組むことにしました。中国に「前人栽樹、後人涼」ということわざがあります。
百年をかけ緑を残します。22世紀のふるさと新潟の人たちのために、そして、かけがえのない地球のために。

『にいがた「緑」の百年物語―木を植える県民運動』をはじめます。

21世紀の木は、22世紀の森になります。

新潟県

Client
Shinmura Design Office

Work Type
Branding

Design Agency
Shinmura Design Office

Green Smile

This design is the mascot of the Shinmura Design Office. The images are used for the business cards and letterheads of Shinmura Design, as well as the face of a watch. There are fifty-four variations of the "Green Smile," each one with a unique personality based on the shape of the leaf used.

Norito Shinmura
新村則人

株式会社 新村デザイン事務所
104-0061
東京都中央区銀座6-7-8
積美堂ビル4F
Telephone 03-3572-5042
Facsimile 03-3572-5045

Shinmura Design Office
SeibidoBldg.4F,6-7-8,
Ginza,Tokyo
104-0061 Japan
shinmura@kk.iij4u.or.jp

161

Client
Self-initiated

Work Type
Print

Design
Jacy Nordmeyer

Run Away to the Mountain: Pop-Up Book

This paper pop-up book is designed to fold away flat into a small box that also serves as its stand. When the lid is opened, a tiny cabin nestled in a three-dimensional mountain forest can be discovered inside.

163

Client	Work Type	Design
Installation	Camille Levesque/ Adeline Golliet/ Jordane Bellavance/ Vanessa Bourgault	

Plant de secours (Rescue Plant)

Who really cares for our planet? Will we be able to save the trees and green spaces that surround us, whether they are in towns or in the countryside? We are living in a state of emergency: instead of destroying plants and trees, we need to take care of them.

PLANT 1

Ce plant de secours est
attend dans sa boite. Il n
mais il pourra toujours vo
soin de votre plant de sec
moment venu ! C'est à vou

Chaque année, de 12 à 15 millions
d'hectares de forêts disparaissent.
C'est l'équivalent de 36 terrains de
soccer par minute.

« Quand
la natur
plus de

Client
Campania Eco Festival

Work Type
Branding

Design Agency
And Then We

Campania Eco Festival 2013 – Official T-Shirt

A shirt that resembles the appearance of the festival it was designed for, as well as representing its ideals. A robotic hand driven by electronic sounds shows the direction of change. A new green economy subverts the power through a special ring, from which grow plants entwined with music notes: reduce, reuse, and recycle.

Photography
MATTEO PASTORIO

Una mano robotica animata da suoni elettronici indica la direzione del cambiamento. Una nuova green economy sovverte il potere attraverso un anello speciale, da cui crescono piante che a ritmo di musica amplificano le note

REDUCE !
REUSE !
RECYCLE !

Client
Gavin Martin Associates

Work Type
Poster Design

Design Agency
Magpie Studio

Gavin Martin's Rabbit

Award-winning printers Gavin Martin Associates promoted their conversion to eco-friendly vegetable inks whilst maintaining their commitment to the highest quality print. The giant rabbit, painstakingly created out of carrots, not only formed a memorable image but kept the local city farm busy for a week.

Unrivalled reproduction — Now with vegetable inks.

To find out more call Phil Le Monde or Gary Bird on 020 7729 0091 or visit us online at gavinmartin.co.uk

Gavin Martin Associates Limited

Client
Self-initiated

Work Type
Promotion

Design
Yu Guiling, Wang Xue

Paper & Plant

The name of this project is Paper & Plant. In ancient Chinese characters, "Paper" is interchangeable with the word "Plant." In this project, plants are given new life through paper.
It is common knowledge that paper is made from plants. This project found the connection between plants and paper through creativity, and reflects the process of conjunction, continuation and alternation of living beings in nature.

Photography
Lee Jun

Client	Work Type	Design
---	Product	Park, Young-Doo

Sprout

Open the book slowly and the bookmark gives the impression of a new bud sprouting from between the pages.

175

Client
City of Alba Adriatica

Work Type
Print

Design
Alessio Romandini

ECO

ECO is an exhibition of sustainable and recycling design. Catalogs, invitations, captions and tags were all made for the exhibition. Five hundred catalogs were printed on black and white laser printer, then folded and bound by hand. Invitations, captions and tags were made by reusing paper boxes disposed of by supermarkets.

Client	Work Type	Design Agency
Coca-Cola	Product	nendo Inc.

Bottleware

Coca-Cola's "contour bottle" has been a brand icon since its inception in 1916. It is also recyclable: after each use, the bottle can be collected, washed and refilled for further use. This tableware collection is made from bottles that have deteriorated over the course of extensive recycling and can no longer be used for their original purpose. The particular green tint (known as "Georgia Green") and the fine air bubbles inspired the designers to create simple shapes that would enhance these traits. The final solution was to create bowls and dishes that retain the bottles' distinctive lower shape, as though the top had been sliced off. The dimpling on the bottle base added to mitigate hot impacts during the production process is not ordinarily a strong visual feature, but is a particular characteristic of glass bottles and is visible to anyone who picks up the bottle to drink. Keeping these ring-shaped dimples on the base of the bowls and plates also helps to convey important messages about the way that glass circulates between people as it's made, used, and recycled for further use, and about the connections it makes between people in this process.

Copyright: Coca-Cola

179

181

Client
SANCCOB

Work Type
Poster

Design Agency
Bittersuite

SANCCOB:
See the Reality

The SANCCOB poster series was designed to alert the public to the rapid decline of the African Penguin population and SANCCOB's on-going efforts to save the species. The object of the campaign is to encourage people to have the foresight to see the problem before it becomes critical. The viewer's visual perception is called into question with the line "See the reality before it's too late" and a call-to-action encouraging the viewer to act now and help save the species by adopting a penguin at SANCCOB. The stark visual language used throughout the series echoes the graphic black and white look of the penguin.

Photography
Andrew Hofmeyr

African penguins are an endangered species in steep decline. So take a closer look at the problem. Act now. **Adopt a penguin** today at www.sanccob.co.za and support SANCCOB and their partners in conservation to save our proudly South African penguins.

SANCCOB™
saves seabirds

SEE THE REALITY BEFORE IT'S TOO LATE

The endangered African penguin needs your help. So don't be short-sighted. Act now. **Adopt a penguin** today at www.sanccob.co.za and support SANCCOB and their partners in conservation to save our proudly South African penguins.

SANCCOB™
saves seabirds

SEE THE REALITY BEFORE IT'S TOO LATE

The endangered African penguin needs your help. Act now and help change this picture. **Adopt a penguin** today at www.sanccob.co.za and support SANCCOB and their partners in conservation to save our proudly South African penguins.

SANCCOB™
saves seabirds

Client	Work Type	Design
Self-initiated	Branding	Tove Bjurström Eriksson

The Waste in Closet

This project was designed for those who have come to accept that they are over-consuming and want to change their habits. It also aims to encourage people to become a part of a more sustainable society, and to encourage others to do the same. The designers attempted to spread this message and promote behavioral changes in a way that would explore the creative parallels between graphic design and fashion.

Client
Cheap Labor

Work Type
Branding

Design Agency
SCIENCEWERK

Cheap Labor

The name "Cheap Labor" reflects that the project was built with only a few cents, and that all materials used in the collateral, including paper and wood, were second-hand, handmade, recycled or reclaimed defect materials.

187

Client
WWF

Work Type
Promotion

Design
Wer Michélle

Interdependence Between Animals & Nature

Plants and animals must coexist to survive. They depend upon each other because each provides something the other needs. Trees provide shade, a place to live, and food for nourishment. Animals spread the seeds of plants and help with pollination. The key idea behind this art was to show society the importance of saving animals by saving nature.

Interdependence between
Animals & Nature
IN ASSOCIATION WITH WWF

PROTECT NATURE
NEAR YOU

Interdependence between
Animals & Nature
IN ASSOCIATION WITH WWF

PROTECT NATURE
NEAR YOU

Client	Work Type	Design
WWF JAPAN	Print	SAKURA.Inc.

Draw the Future

This project is intended to protect animals in the Okinawa region of Japan. This series of posters expresses the intention of animal protection.

Illustration
Takeshi Aoki, Kakuho Fujii

193

Client	Work Type	Design Agency	Illustration
TRAFFIC	Print	SAKURA.Inc., Shogo Seki	Takeshi Aoki

Living with Biodiversity

These posters are concerned with the issue of biodiversity, and convey a message of sea-life protection.

獣達の子孫を守れ。

もっとも凶暴な獣が、人間であってはならない。

今、地球上の多くの獣達が絶滅の危機に瀕しています。狩猟による個体数の減少だけではなく森林の伐採によって彼らのすみかを奪うことも、絶滅への後押しとなるのです。アフリカゾウの象牙、ワニの革製品、ペット用に取引されるインドホシガメなど、私たちが子どもに未来を託すように、地球の生態系は獣たち子孫によって保たれるのです。

TRAFFIC WWF IUCN Draw the Future

Client
Self-initiated

Work Type
Print

Design
Ursula Villalba

Icon Set – Recycle

Icon set – Recycle is a personal project with one goal: to promote and raise awareness of recycling and environmental care. The designer developed a set of 23 icons, divided into five globally recognized groups: glass, plastic, paper and cardboard, organic waste, and toxic waste. Each group has a main color and several variants. Different posters were designed, printed, and given away to help promote this important topic.

4000 AÑOS
Es lo que tarda una botella de vidrio en desintegrarse.

Acortemos ese tiempo.
Dale un nuevo ciclo de vida. Reciclá.

30 AÑOS

Es lo que tarda un
aerosol en desintegrarse.

Acortemos ese tiempo.
Dale un nuevo ciclo de vida. Reciclá.

Client
WWF

Work Type
Print

Design
Gonzalo Menevichian

Energy Campaign

Climate change threatens the fragile balance of our planet's ecosystems and significantly increases the risk of species extinction. These posters were designed in order to increase the awareness of how energy utilization effects things happening around us.

HIGH-CONSUMPTION ITEMS
Promote the efficient use of energy saving lamps, they save 80% more energy compared to incandescent lamps.
Require responsible behavior on and off the electronics.

EFFICIENT USE OF ENERGY
In the US, the corresponding figures would be 17 billion kWh of electricity and 27,000,000,000 lb CO2. The most efficient global measures to reduce emissions of greenhouse gases.

CLEAN ENERGY
The European Council for Renewable Energy global energy scenario developed as a practical exercise to show how it can attain its aims of a strong push to reducing carbon dioxide (WWF).

POLLUTING FUELS.
The destruction of the global climate system, generated by acts of such a character as to lead to an increase of its temperature 3.3-7°F compared to preindustrial times.

Client
Morinoko Nursery, Hibinosekkei + youji no shiro, Oiseau

Work Type
Branding

Design
Chikako Oguma

Photography
Masako Nagano

Morinoko Nursery

This project was made for a nursery school called MORINOKO, which means "children of woods." The concept's intent is to reflect the diversity of the children in the nursery school. The logo represents the variety of plants and animals that live in the woods. The poster belongs to the Museum of Design Zurich.

社会福祉法人 恵比寿会
森の子保育園
MORINOKO NURSERY

住　　　所：立川市砂川町8-30-6
電話番号：042-538-0729

Children in the Forest

森の子のアソビ通りには
Welcome to the "Asobi" street of Morinoko

こどもたちの大好きがいっぱい
There are a lot of things you love

こんにちはガラス向こうの森のシェフ
Saying hello, the Forest chef is in the kitchen

こもれびのランチルーム
and sun-shining lunch is in the lunchroom

ブルーやオレンジの秘密基地がおまちかね
You will be found the colorful secret base

屋根から見える大っきなお山
Going on the roof, can be seen the big mountain

階段あがると広がる原っぱ
Going up the stairs, can be seen, the field

ワクワク楽しい赤いお家
Moreover, there is a red house you wait

森の子たちが根を張り枝をひろげ
We wish you playing will carry you

すくすく育っていきますように
and wish you growing up fine toward the future

社会福祉法人 恵比寿会
森の子保育園
MORINOKO NURSERY

社会福祉法人　恵比寿会
森の子保育園
MORINOKO NURSERY

The Children Who Love People, Nature, and Themselves — 森の子保育園 しか	The Children Who Love People, Nature, and Themselves — 森の子保育園 たぬき
MORINOKO NURSERY	MORINOKO NURSERY
The Children Who Love People, Nature, and Themselves — 森の子保育園 きつね	The Children Who Love People, Nature, and Themselves — 森の子保育園 うさぎ
MORINOKO NURSERY	MORINOKO NURSERY

Client
Self-initiated

Work Type
Promotion

Design
Namsung Kim

- Endangered Animals Graphic Archives
-

This graphic design is intended to raise awareness of the numerous endangered animals that are disappearing.

205

207

Client	Work Type	Design Agency
XD	Product	XD Design

Solar Suntree

Suntree uses nine solar "leaves" to charge your mobile phone or MP3 player using solar cell technology. A real eye-catcher for any desk, Suntree has a powerful 1350mAh rechargeable lithium battery inside. The solar charger has a USB output and mini-USB input. Solar Suntree consists of a handmade bamboo tree trunk and nine white ABS leaves with a solar surface.

Client
Self-initiated

Work Type
Product

Design
Antoine Tesquier Tedeschi

Sustainable Habit Reminder

Sometimes being environmentally responsible is as simple as pushing a switch to turn off lights and electronics when they are not in use. These wall stickers are intended to be fixed to the wall around sockets and light switches, where they can provide energy consumers with a friendly reminder of the environmental costs of power generation. The stickers are made from PVC-free plastics.

Client	Work Type	Design
---	Promotion	Koshi Kawachi

MANGA Farming

The idea of growing plants in used comics has grown out of Koshi Kawachi's respect towards the art of cartoons as well as the Earth. Comics inspire dreams in a manner similar to the way that the earth supplies nutrients for crops to grow.

213

Client
More Trees Exhibition

Work Type
Promotion

Design Agency
Nakano Design Office Co., Ltd.

More Trees

"More Trees" exhibition was initiated by a forest preservation organization. The poster was designed as if the building were a single large tree. It addressed the issues of Japanese forest preservation and advocated for taking action by planting more trees.

218

Client
Universidade de Lisboa

Work Type
Promotion

Design Agency
P-06 Atelier

MNHNC (Natural History and Science National Museum)

This is a communication project for the Natural History and Science National Museum in Lisbon. The exterior signage consists of two 3D displays in the facade that are covered with images that allude to museum exhibits even from a distance.

Escola Politécnica d
Estabelecimentos anexos

Real Colégio
nete de Física
Colégio dos Nobres

Do Noviciado da Cotovia
ao Colégio dos Nobres

Client
EHMA

Work Type
Branding

Design Agency
BARDO

VOS.QUE

Bardo was challenged to make a provocative international display for EHMA, an environmental organization, to raise awareness of indiscriminate logging worldwide.

223

Client	Work Type	Design Agency
WWF	Promotion	Grey Group Singapore

Umbrella Tree

On Earth Day, the residents of Dragon Hill in Ho Chi Minh got a reminder of the effects of deforestation. Instead of leaves, the Umbrella Tree had over 100 umbrellas to alert people of the importance of shade in these times of global warming. As people sought shelter under the tree, they had the opportunity to buy an umbrella and donate to global reforestation efforts. Although all of the umbrellas were gone within hours, donations continued to pour in throughout the day.

225

Client
Finland Railways Corp.

Work Type
Illustration

Design
Kustaa Saksi

Finnish Railways

Finnish railways were rebranded to create a journey of discovery through the diverse flora and fauna of Finland. Each illustration draws forms from VR's identity, making the images both unique and quintessentially Finnish.

Client
China Environmental Protection Foundation

Work Type
Print & Outdoor

Agency
DDB Shanghai, DDB China Group

Green Pedestrian Crossing

This project is a creative, interactive outdoor advertisement, using the footpath and road as the canvas. The theme was "More Walking, Less Driving. Let's Create a Greener Environment Together." It was designed to encourage the general public to think of their impact on the environment and to realize we all need to walk more and drive less. The interactive aspect of the advertisement was aimed at encouraging behavioral change and creating personal experiences that would generate "word of mouth" and "human interest" media angles.

Photography
Keno Zhao
Copy
Jason Jin
Illustration
Jody Xiong
Typography
Jody Xiong, Jerry Cao

229

INTERVIEW

WWF TOGETHER APP

Starting from the U.S. to the globe, a spectacular WWF app featuring panda origami expands awareness to conserve the planet.

SO... SOAP!
I'MPERFECT

In Hong Kong, where resources are valued over gold, local designers wisely take advantage of repurposed wastes for good.

HAZE

In the mainland China, graphic design reaches for the right of expression for the public interests and calls for real actions in fighting air pollutions.

The playful and educational attributes of origami fit perfectly with our goals for the app to educate users through fun, interactive components featuring photos, videos and facts to expand awareness of the issues WWF works to solve toward conserving the planet.

Diane Quigley, *Washington D.C.*

Diane Quigley is the website and mobile app director at World Wildlife Fund's United States office in Washington, D.C., where she directs the vision for and execution of the organization's primary digital channels. With close to 20 years of digital experience, she has supported digital strategies across a variety of industries.

"My family shops for groceries daily. My husband rides his bike or walks to the store to get just what we need for the day."

WWF TOGETHER APP

What green deeds do you practice every day? What bad things do you still do to Mother Nature every day?
My family shops for groceries daily. My husband rides his bike or walks to the store to get just what we need for the day, reducing food waste. We do not use clean energy. Because we rent our home, we do not get to decide the source of our power. If we owned our own home, I would select solar power.

Green design represents the positive energy or "+" energy. Green design believes collective actions can make a change: action + action + action = changes. What else can you think of when it comes to the associations of "+". Please name five of them.
Positive outcomes. Energy-saving. Waste-reducing. Awareness-building. Comprehensive.

What environmental issues are you concerned with recently?
Energy consumption and food waste.

WWF Together App combines interface design with the time-honored art of paper folding. How did you manage to house these two contrasting things in one room?
AKQA, the agency WWF hired to build the app, came up with the idea to use origami as a major design component. The playful and educational attributes of origami fit perfectly with our goals for the app to educate users through fun, interactive components featuring photos, videos and facts to expand awareness of the issues WWF works to solve in order to conserve the planet.

WWF Together App is free, and has a broad range of users. What has been the effect of campaign so far, especially on kids?
While we did not intend for the app to appeal to children only, we get a lot of feedback from children, parents and teachers that kids love the app and its educational content and interactive components. We reached more than one million downloads in less than a year, which far exceeded our expectations for the distribution of our content. Additionally, we've seen great sharing of the content over social media, which was a primary goal of the campaign. The more awareness we can build about the environmental issues facing the amazing animals featured in the app, the more we can change behavior to benefit conservation of the planet.

234

Since it became WWF's logo in 1961, the giant panda has become a symbol of conservation worldwide, drawing attention to the world's endangered species and the solutions necessary for humans to live in harmony with nature. But more than just a symbol, the panda is a remarkable conservation success story. In the past 30 years, reserves in China have grown from 8 to more than 60 and the panda population has doubled.

GIANT PANDAS
Population in the wild
1,600
Habitat
FORESTS
Weight (lbs.)
220-330
Height
5 FT.
Distance from you (mi.)
7,638

HABITAT LOSS
Once widespread, panda habitat is increasingly fragmented. In fact, many panda groups are now isolated in narrow belts of bamboo less than a mile wide. This is reducing the prospects of a healthy and viable panda population.

THREATS

THEY EAT 26-83 POUNDS OF BAMBOO A DAY

SINCE 1980
WWF WAS THE FIRST INTERNATIONAL CONSERVATION ORGANIZATION INVITED INTO CHINA TO HELP WITH PANDA CONSERVATION.

Building a future in which people live in harmony with nature.

TOGETHER

WWF

START

THEY CAN CONSUME UP
TO 88 POUNDS OF MEAT
AT A TIME

THERE ARE AS FEW AS 3,200

THEY CAN SEE SIX TIMES BETTER IN THE DARK THAN HUMANS

THEIR TERRITORY CAN EXTEND UP TO 386 SQUARE MILES OF SPACE TO ROAM

THERE ARE AS FEW AS 3,200 LEFT IN THE WILD

The world's most amazing animals in one app.

TOGETHER

WWF

While its product quality and social mission are the core values, creativity and design have played a crucial role in putting the elements together as well as attracting the attention of customers and media.

CoDesign Lab, *Hong Kong*

Founded by Eddy Yu and Hung Lam in 2003, CoDesign specializes in brand identity design. In 2011, Eddy and Hung established CoLab, a collaborative platform for social innovation through design. In 2012, Eddy and Hung co-founded 3X with partners from Guangzhou, Beijing, Kuala Lumpur and Copenhagen to further explore design for social innovation on an international level.

"I try to avoid buying bottled water and value the life span of daily objects I am using."

SO... SOAP! I'MPERFECT

What green deeds do you practice every day? What bad things do you still do to Mother Nature every day?
I try to avoid buying bottled water and value the life span of daily objects I am using.
Unfortunately, I have been eating quite a lot of meat, taking long showers and making way too many printouts at work.

Green design represents the positive energy or "+" energy. Green design believes collective actions can make a change: action + action + action = changes. What else can you think of when it comes to the associations of "+". Please name five of them.
Values, happiness, multi-dimensions, creativity, synergy.

What environmental issues are you concerned with recently?
Bottled water, food waste.

So... Soap! is a sustainable design, not just environmentally friendly but also economically and socially viable. It involves corporations, brands, NGOs and social minorities, and each party constitutes a necessary section of a large circle. How do you come up with this circle and which section(s) is at its center?
So... Soap! was actually founded by a woman, Bella Ip, and it had already included all the mentioned elements before we were involved. While its product quality and social mission are the core values, creativity and design have played a crucial role in putting the elements together as well as attracting the attention of customers and media.

What is the aesthetic behind "I'mperfect"? How does this aesthetic relate to the overall Green concept?
I would describe the look and feel of I'mperfect as simple, down-to-earth and honest. Moreover, we mainly use black and white typography with ample white space for our communications. We believe this aesthetic approach saves a lot of time (i.e. engery) and resources, not only during the design but also the print and production process.

SUPPORT SO...SOAP!
支持區區肥皂

① 我有膠樽可以回收
BY REUSING THE BOTTLES

當你買區區肥皂時，除了因為想親近有機生活外，其獨特的樽身設計也很吸引吧！你大概想不到，所有區區肥皂樽也是回收得來的！

Apart from the calling to engage in organic living, part of the reason for buying So...Soap! may have been its gorgeous bottle.

了解更多 Read more

區区肥皂

I'mperfect is simple, down-to-earth and honest.

I'MPERFECT

Zijns, *Beijing*

Zijns is the researcher for IdeaWorks Synthesis Design Research Institute, and vision researcher and advocate of the Oriental Philosophy Design Theory. In 2011 he and Mi Shijie, a vision researcher, cofounded the IdeaWorks Synthesis Design Research Institute. He coauthored the book Design Belief – Power of Profession.

"I am more ready for green practices that can become a part of my life, i.e. packing leftovers when dining out, using eco bags, or turning off lights when leaving a room."

HAZE

What green deeds do you practice every day? What bad things do you still do to Mother Nature every day?
I am not into any one-time green deed, because it doesn't make much sense to me. I am more ready for green practices that can become a part of my life, i.e. packing leftovers when dining out, using eco bags, or turning off lights when leaving a room.

Green design represents the positive energy or "+" energy. Green design believes collective actions can make a change: action + action + action ... = changes. What else can you think of when it comes to the associations of "+". Please name five of them.
Five are too many for me. But I quite like "+". It bridges two people and this bridge is what we call "communication." Via dialogue, people find common grounds to support their thoughts and take action.

What environmental issues are you concerned with recently?
The foggy and hazy weather shrouding China now.

Tell us the background of Haze.
Haze is the VI for an ongoing green campaign "Say No to Haze!", which is a collaboration between 15 design associations in China. I am one of the people who launched this campaign.

Haze is designed for an on-going campaign initiated by Chinese graphic designers. As a member of it, what changes do you see in the role that creative talents (both as individuals and collectively) play in addressing the real social issues emerging in China nowadays?
First of all, I want to share my understanding of what design is. Design is media. Design conveys emotions, concepts, art and aesthetic values. This is especially true with graphic design, considering its weak functionality. When design approaches media, it reaches for the right of expression. At present, however, designers are still following mass values. This is because for so long, designers have been assigned with supplementary work for a given task. But now some designers are beginning to develop projects independently. This change brings the designer back to the front of industry. In terms of lifestyle, designers, with the aid of new media technology, become the demonstrators of new ways of life.

The campaign reaches out to people in China and is fed back by the masses via personal mobile devices. How does this kind of new media-powered interaction distinguish itself?
Medium is changing all the time. After all, medium is just a vehicle for communication. What we're concerned with is not medium but the behavioral mode of people. Undeniably, new media change the way people behave, from a passive recipient into an active paticipant. This is why we added interactive components in the campaign to create a free space for people to express themselves.

SAY NO TO HAZE!
拒絕霧霾全民行動

Say No to Haze!
The 1st Collection Initiative for Public Posters about Haze

Haze is the VI for an ongoing green campaign "Say No to Haze!", which is a collaboration between 15 design associations in China.

創新性
創新理念有創意閃光點

積極性
積極向上的樂觀精神

多元性
創新視覺元素或多樣視覺元素

時代感
表現青年一代的時代精神

藝術性
給人以思考的視覺感受

Haze

霾

Say No to Haze!
The 1st Collection Initiative for Public
Posters about Haze

首屆中國霧霾主題公益海報作品展

Say No to Haze!
The 1st Collection Initiative for Public
Posters about Haze

Haze

霾

首屆中國霧霾主題公益海報作品展

Index

3nity

www.3nitydesign.com

3nity is a branding and visual identity consultancy firm based in Kuala Lumpur, Malaysia. 3nity has created and managed brands as well as corporate identities and communications of various organizations – from multinationals to cultural groups, as well as products and services.

p.034-035, 044-045

A

Akaoni Design

www.akaoni.org

Akaoni Design is a creative studio based in Yamagata, which boasts excellent packaging designs, posters, books, brochures and websites. Their extensive portfolio is characterized by bold colors and interesting typography, and carries the impact of Japanese traditions.

p.058-061

AKIHIRO KUMAGAYA

www.aklog.alekole.jp

Akihiro Kumagaya was born in Tokyo, 1984. He established ALEKOLE, a Tokyo based studio, in 2012.

p.078-079

Alessio Romandini

www.behance.net/alessioromandini

Alessio Romandini works across many disciplines, including identity design, web design and development, art direction and print design.

p.176-177

Alonglongtime

www.alonglongtime.me

Alonglongtime is a Hong Kong based multi-disciplinary design house, dedicated to brand identity, printed matters, and packaging for clients from corporate, leisure, retail and art and cultural disciplines.

p.070-071

And Then We

www.and-then-we.com

And Then We is a suspended space in Milan, dealing with products, graphics and web design. And Then We is a union of thoughts, a place to amass, mould, show things and let it be.

p.166-167

Andreas Engesvik

www.andreasengesvik.no

Andreas Engesvik was born in 1970. He graduated in history of art from Bergen University (1991/1995) and then studied design at the National College of Art and Design. In 2000 he received his degree in design, and in the same year founded the Norway Says studio. In 2009, after 6 years working with others, he opened his own studio, Andreas Engesvik in Oslo.

p.022-023

Antoine Tesquier Tedeschi

www.hu2.com

Hu2 Design was created in 2007 in the cold East London district of Shoreditch.

p.210-211

Appree

www.appree.net

Appree is a product company established in 2008 that provides a variety of office supplies.

p.038-043

B

Bardo

www.makebardo.com

Bardo is passionate to work with projects focusing on social and environmental responsibility, because the world needs even small actions.

p.222-223

Bentu

www.bentudesign.com

Bentu is an experimental high-density design institute without limitations or boundaries. Using the basic methods of design, Bentu influences reality and transforms the world by exporting ideas. Its fields include but are not limited to space design, environmental design, graphic design, art design and product design.

p.094-097, 102-103

Bittersuite

www.bittersuite.co.za

Bittersuite is an award-winning Cape Town advertising agency specializing in design, packaging, corporate identity, creative brand rejuvenation, launches and activations.

p.182-183

C

Cecilia Hedin

www.ceciliahedin.com

Cecilia Hedin, born and raised in rural Sweden, is a designer and illustrator living in foggy San Francisco. Her passion lies where playful creativity crosses with the natural world, and she dreams of living in a really well-designed tree house.

p.122-123

Chikako Oguma

www.chikako-oguma.com

Oguma, a member of JAGDA, is an art director. She works on total design directions such as CI, VI, and branding.

p.200-203

Co-design

www.codesign.com.hk

Founded by Eddy Yu and Hung Lam in 2003, CoDesign specialized in brand identity design. In 2011, Eddy and Hung established CoLab, a collaborative platform for social innovation through design. In 2012, Eddy and Hung co-founded 3X with partners from Guangzhou, Beijing, Kuala Lumpur and Copenhagen to further explore design for social innovation on an international level.

p.238-243

D

Dan Heron

www.danheron.co.uk

Dan Heron is a freelance Graphic Designer from Manchester, UK.

p.120-121

DCELL

www.dcell.co.kr

DCELL means design cell. The cell is the basic structural and functional unit of all known living organisms. Their basic unit is design.

p.112-113

DDB Group Shanghai

www.ddbchina.com

DDB China Group comprises DDB, DDB Guoan, Tribal Worldwide and RAPP with offices in Shanghai and Beijing. The agency is one of the most awarded agencies across Greater China and is a leader in creativity and effectiveness.

p.228-230

Dora Pete

www.behance.net/porah

Dora Pete studied as an industrial product design engineer and applied graphic artist. She now works as a graphic designer at a small local advertising agency in Hungary.

p.118-119

Dry Creative Project

www.drycreativeprojects.com

DRY is a studio with focus on creative direction, art direction and design in graphic design, product design and packaging.

p.088-089

E

EDING:POST

www.ed-ing-post.com

EDING:POST is a design laboratory based in Tokyo, Japan. It designs for various products, such as coffee, fabrics, fireworks and letters.

p.048-051

G

GARBAGE BAG ART WORK (C)
MAQ inc.

www.gba-project.com

People generate a significant amount of garbage as they go about their daily lives. In Japan, people separate their garbage into different types and place it into semi-clear or transparent bags for disposal. The garbage is collected on particular days of the week in each community, and on these mornings garbage is placed in the appropriate locations on street corners or roadsides. Until the garbage truck comes around to pick them up, mounds of garbage bags on the streets are a common sight in Japan.

p.012-013, 116-117

Gemma Warriner

www.behance.net/gemmawarriner

Gemma Warriner is a Visual Communication Designer based in Sydney, Australia. Her work is compliant with her interest in food design and information visualization, and she seeks to engage, inform and delight an audience beyond the like-minded.

p.104-105

Gianpaolo Tucci

www.gianpaolotucci.com

Gianpaolo Tucci is an award-winning Italian designer, currently based in Berlin. Gianpaolo Tucci's work celebrates conceptual visions of the future of people's behavior of using technology.

p.090-091

Gonzalo Menevichian

www.behance.net/gonzalomenevichian

Gonzalo Menevichian is an Argentine graphic designer who specializes in both print and motion supports.

p.198-199

Grey Group Singapore

www.grey.com

Founded as a one-man, one-room retail shop in New York City's garment district, Grey now comprises more than 1,000 people between the New York City flagship of our 96-country network and Grey San Francisco.

p.224-225

H

Hanson Chan

www.voyrd.com

Hanson Chan is an imaginative creative specializing in visual communication. He has the pleasure of working with talented creatives who share the compulsion to speak in the wonderful, fierce vocabulary of visual media. He's dedicated to direction, design, interactivity, and representation services to bring all manner of projects to life.

p.072-073

I

Insignia Creativa

www.insigniacreativa.com

Insignia Creativa is a studio which has been running for 12 years. It specializes in graphic design, specifically in branding, packaging, posters, signage, visual identity and illustration.

p.068-069

J

Jacy Nordmeyer

www.behance.net/jacy

Jacy Nordmeyer was born and raised in the city of Chicago. She recently graduated from The School of the Art Institute of Chicago with a BFA focused on Illustration, Sculpture, and Object Design. She is currently creating designed paper structures, slip cast ceramics, and accessories as art objects.

p.162-163

Jiajie (Roger) Wang Project

www.rogerwangdesign.com

Roger is a multi-disciplinary designer primarily focused on visual and graphic works based in San Francisco.

p.128-129

Justin Joshua

www.behance.net/justinjoshua

Justin Joshua is Creative Group Head in Y&R, a marketing and communication company in Cape Town, South Africa. He is focused on advertising, art direction and creative direction.

p.132-133

K

KaCaMa Design Lab
www.kacama.hk

KaCaMa Design Lab is a Hong Kong-based product designer who specializes in reusing post-consumer waste materials.

p.148-149

Kenichi Matsumoto
www.behance.net/kenichi_matsumoto

Kenichi Matsumoto was born in 1980, in Tokyo. In 2004 he received a degree in Graphic Design from Tama Art University. He was awarded with the Bronze Prize at The One Show Design, 2009 and ADC YOUNG GUN, 2010. He started MOTOMOTO inc. in 2013.

p.009-011

Kolle Rebbe GmbH
www.kolle-rebbe.de

KolleRebbe, quite simply, believes in common sense. They conduct business with entrepreneurial intelligence – capitalizing on cooperative, interdisciplinary approaches and transcending the boundaries of culture and media.

p.114-115

Koshi Kawachi
www.koshikawachi.com

Koshi Kawachi is a designer and artist based in Tokyo.

p.212-215

Kustaa Saksi
www.kustaasaksi.com

Artist Kustaa Saks builds fantastical worlds of playful, paradoxical, and troubling-yet-inviting shapes, environments, and psychedelic atmospheres.

p.226-227

L

Latysheva Ksenia
www.behance.net/Latysheva

Latysheva Ksenia is a designer from Russia, who specializes in the field of graphic design. She is interested in projects that can help preserve nature and draw public attention to the problems of pollution and the destruction of natural resources.

p.066-067

Laura J. Merriman
www.laurajmerriman.com

Laura J. Merriman is a graduate of Ball State University with a BFA in Visual Communication and a minor in Landscape Architecture.

p.130-131

M

Magpie Studio
www.magpie-studio.com

Magpie Studio ranked the 6th in the UK by Design Week in the 2013 Creative Survey, a results-driven analysis of the top 50 UK design agencies.

p.168-169

Mathery
www.mathery.it

Mathery is a multidisciplinary design studio who works on a large variety of projects, from product and industrial design to video and photography.

p.030-031

Matteo Cibic Studio
www.matteocibicstudio.com

Matteo Cibic Studio is a brand and design consulting firm specializing in brand identity through storytelling and design.

p.020-021

Maykol Medina (MaMe)
www.mamecreativebeans.com

Maykol Medina (MaMe) is a creative specialized in branding.

p.154-155

Meb Rure Design Studio
www.meb-rure.com

Istanbul based designer MebRure graduated from the Industrial Design department of Middle East Technical University. She has been leading MebRure Design Studio since 2012. Her designs have been published and exhibited internationally. She won the IMMIB Industrial Design competition both in 2011 and 2013. She was also awarded by Italian Domus Academy in "Fill the Future" competition in 2011. Recently, MebRure founded a new company, "RURE," which aims to produce modern furniture pieces.

p.144-147

Meirav Barzilay
www.meiravbarzilay.com

Meirav Barzilay is an Israeli product designer, focusing on products for the home. He applies clear and intriguing concepts to design, combining industry and craft.

p.098-099

Mirim Seo
www.mirimseo.com

Mirim Seo works at Anthropologie as a graphic designer in Philadelphia, PA. She likes to craft, sew and illustrate animals. All her works are eco-friendly and very minimal because she is trying to create sustainable design that is not harmful to the environment.

p.142-143

moodley
www.moodley.at

moodley brand identity is an owner-led, award-winning strategic design agency with offices in Vienna and Graz. Since 1999, moodley has worked together with their customers to develop corporate and product brands, which live, breathe and grow. moodley believes that their key contribution is to analyze complex requirements and develop simple, smart solutions with emotional appeal – whether corporate start-up, product launch or brand positioning. The team currently consists of about 60 employees from 7 different countries.

p.084-085

N

N.G. Inc
www.nginc.jp

Hiroaki Naga was born in Tokyo in 1957 and established N.G. INC. in 1989 after working for Breakfast Inc. He is a member of Tokyo ADC, Tokyo TDC, and JAGDA.

p.018-019

Nakano Design
www.nakano-design.com

Takeo Nakano graduated from the department of Visual Communication Design at Musashino Art University in 2001. He established Nakano Design Office in 2011.

p.216-219

Namsung Kim
www.sshwarang.net

SungSil Graphics is a graphic design boutique in Korea.

p.204-207

nendo Inc.
www.nendo.jp

nendo was founded in 2002 by Oki Sato, driven by the desire to create little surprise moments in daily life. Overflowing with imagination, nendo has been responsible for a prolific amount of projects in architecture, interior, product and graphic design.

p.028-029, 178-181

NHOMADA
www.nhomada.com

Diego Leyva is the Creative Director of NHOMADA. He creates concepts and design experiences to achieve exquisite results.

p.134-135, 140-141

O

O-lab
www.o-lab.jp

O-lab is an office that works to create the sense of pleasant surprise, "Oh," through design. O-lab's objective is to contribute to the success of businesses through design and branding that provokes this "Oh," and to follow creative strategies to make this pleasing experience a constant one. O-lab's ultimate goal is to make people's lives and society better, and filled with many "Ohs."

p.110-111

P

P-06 Atelier
www.p-06-atelier.pt

P-06 Atelier is an international award-winning firm specializing in communication and environmental design on a wide range of scales. Based in Lisbon, Portugal, the studio was founded in 2006 by partners Nuno Gusmão, Estela Estanisiau, Pedro Anjos and Catarina Carreira. It has since undertaken a variety of projects from complex, large scale way-finding systems to museum and exhibition design.

p.220-221

Paprika
www.paprika.com

Paprika is a graphic design and strategic marketing firm specializing in business communications services.

p.150-151

Park, Young-Doo
www.doodoo-ds.com

doodoo Design Studio uses various methods to create special memories in everyday life.

p.174-175

Pati Nunez
www.patinunez.com

Since 1985, Pati Núñez Associats studio has specialized in branding and packaging design. They have extensive experience with successful products.

p.080-081

Pei Liew
www.peiliew.com

Pei Liew is a design student in Los Angeles with an interest in creating projects that are beautiful in unconventional ways.

p.124-127

Presek Design Studio
www.presekstudio.wix.com/presekstudio

Presek, a design studio based in Belgrade, is focused on creating industrial, interior, furniture, packaging and graphic design.

p.100-101

Q

Qiyun Deng
www.cargocollective.com/qiyun

Qiyun Deng is a Chinese designer recently graduated from the Master Product Design at ECAL (University of Art and Design Lausanne). "Graft" was her diploma project.

p.052-053

R

Reformer Design Studio
www.reformer.hk

Reformer is a Hong Kong-based design studio founded by Wai Chan David in 2012. He believes that design should not just make something beautiful, but improve it.

p.074-075

Ryohei Yoshiyuki to job
www.ry-to-job.com

Ryohei Yoshiyuki took an internship at Atelier Arnout Visser, and set up Ryohei Yoshiyuki to job studio after graduating from Design Academy, Eindhoven.

p.014-015

S

Saatchi & Saatchi (CT)
www.saatchi.com

Saatchi & Saatchi has grown from a start-up advertising agency in London in 1970 to a global creative communications company headquartered in New York with 130 offices in 70 countries and over 6000 employees. Saatchi & Saatchi is part of the PublicisGroupe, the world's third largest communications group.

p.136-137

SAKURA.Inc
www.sakura-tokyo.jp

Sakura is a creative agency working in Tokyo. They produce graphic design, video production, and web sites while caring for the environment.

p.016-017, 192-195

SCIENCEWERK
www.sciencewerk.net

Sciencewerk® (est. 2011) is an independent design studio based in Indonesia.

p.186-189

Shinmura Design Office
www.shinmura-d.co.jp

Norito Shinmura was born in 1960 in Japan, the last of eight siblings in a fisherman's family. He established Shinmura Design Inc.

p.156-161

Stefan Zimmermann

www.deszign.de

Stefan Zimmermann received his degree in Communication Design (BA) in 2012 at Faculty of Design in the FH Aachen, University of Applied Sciences. During his studies and work he has focused on corporate design, typography and web design.

p.138-139

Studio Intraligi

www.studiointraligi.com

Philippe Intraligi is a New York based graphic designer with international experience in corporate design, fashion and branding.

p.152-153

Studio Note

www.studio-note.com

Norihiko Terayama was born in Tochigi Japan, 1977. He graduated from CHUOUKOU Architecture Department in 1998 and from KIDI (Kanazawa International Design Institute) in 2001. In 2006, he graduated from Design Academy Eindhoven; he set up studio Note in the same year.

p.082-083

Suisei

www.suisei-suisel.com

HIGUCHI Kentaro values the traditional culture of Japan and has been engaged in diverse fields such as branding and packaging. He used to work as art director for an ecological movement and was responsible for the visual identity of a toy museum, among other things.

p.054-055

T

Tetusin Design Office

www.tetusin.com

Senzaki Takayuki works as a graphic designer and art director, based in Kyushu. His focus is on design using plant-themed graphics.

p.056-057

The Institute of Critical Zoologists

www.criticalzoologists.org

The Institute of Critical Zoologists is the first interdisciplinary scholarly centre dedicated to promoting critical dialogue on the principles and practices of animal spectatorship and animal-related policies in the fields of social sciences, ecology and the arts. The Institute employs a variety of methods to pursue its mission, engaging in research, classification and exhibition.

p.086-087

The Mainichi Newspapers / ITOCHU

www.mainichi.co.jp
www.itochu.co.jp

The Mainichi Newspapers Corporation is the oldest Japanese newspaper, founded in 1872. The Mainichi is one of the "big three" of Japanese newspapers in terms of circulation and employee numbers, and has more than 70 associated companies, including TBS (Tokyo Broadcasting System), MBS (Mainichi Broadcasting System) and the Sports Nippon Newspaper.

ITOCHU Corporation is a Japanese general trading company founded in 1858. Their wide field of business includes textiles, machinery, information and communications-related products, metals, products related to oil and other energy sources, general merchandise, chemicals, and provisions and food.

p.024-027

Tove Bjurström Eriksson

www.tovebjurstrom.com

Tove Bjurström Eriksson is a graphic designer and art director from Sweden who likes to explore and work within different fields of visual communication, such as print, digital media and spaces.

p.184-185

Tsuyoshi Hayashi

www.tsuyoshihayashi.com

Tsuyoshi Hayashi is a Japanese designer who graduated from Design Academy Eindhoven's Man and Well-Being Department in 2012. He received an internship at Piet Nein Eek, where his experiences taught him the significance of simplicity in design and approaches such as analyzing the material, structure and story of a project to ensure outstanding results. He opened his design studio in Eindhoven in 2013, and currently works on the research of factory waste and its locality.

p.092-093

TUTU Lollipops Studio

www.tutu.lt

TU-TU lollipops manufacture is highly focused on design, taste and quality. The company is based in Vilnius, Lithuania, and was founded by Smilte Bagdziune and Elvita Brazdylyte. It combines experience in design, fashion and art with a youthful passion for food design. Recent TU-TU clients are in design, fashion and healthy food stores around the world.

p.076-077

U

UMA / design farm

www.umamu.jp

Japanese design studio UMA/design farm was established by architecture graduate Yuma Harada in 2007. Their exquisite skills in designing books, graphics and exhibitions earned them many publications and awards in Japan and overseas.

p.106-107

Université du Québec à Montréal

www.designuqam.ca

Graphic Design students Camille, Adeline, Jordane and Vanessa wanted their fellow students to react and act towards a greener future. They worked under the supervision of Lynelefebvre at UQAM.

p.164-165

Ursula Villalba

www.behance.net/UrsulaVillalba

Ursula Villalba is a graphic designer with a Bachelors Degree from Facultad de Arquitectura, Diseño y Urbanismo (Buenos Aires, Argentina).

p.196-197

V

Victor Design

www.victad.com.tw

Victor Design was established in 1998, specializing in brand, VI, package and advertisement.

p.064-065

W

Wang Xue

www.behance.net/snowwang1990

Wang Xue is a graphic designer based in Guangzhou, China.

p.170-173

Wataru Yoshida

www.wataru-yoshida.com

Wataru Yoshida was born in Tokyo, Japan. Wataru was graduated in graphic design from Tama Art University.

p.062-063

Wer Michèlle

www.wermichelle.com

Wer Michèlle is a Tbilisi based graphic designer specializing in poster design and typography.

p.190-191

WWF

wwf.panda.org/?referer=wwfhk

For 50 years, WWF's mission has been to create a future in which people live in harmony with nature. A core part of that mission is saving wildlife from threats like poaching, habitat loss and overuse of natural resources. This important work doesn't just help wild animals; it also contributes to people's health and well-being.

p.232-237

X

XD Design

www.xd-collection.com

XD Design believes design is one of the most effective ways to differentiate oneself. Therefore, design is everywhere. It is not about adding features, but elegant solutions that eliminate unnecessary complexity.

p.032-033, 208-209

Y

yuruliku

www.yuruliku.com

"yuruliku" was named by combining the words "yururi," which means "relaxing," with "yukkuri," which means "slowly" in Japanese. They explore new styles in stationery. Yuruliku's works are based on "little humor" found in everyday life. They cherish the importance in expressing "enjoyment," "simplicity," and "fresh discovery."

p.108-109

Z

Zeup Design Studio

www.zeup.co.kr

Zeup design studio creates designs that anyone can take part in.

p.036-037

Zhan Bokai

www.zhanbokai.com

Born on May 21, 1984, Taiwanese designer Zhan BoKai was originally trained in the fine arts. His work later branched out into the areas of graphic design, interactive design, and digital art. He believes that the designer's job is to simplify complexity by using the clearest and most powerful images to communicate effectively.

p.046-047

Zijns

www.artist.cn/zijns

Zijns is the researcher of IdeaWorks Synthesis Design Research Institute, and vision researcher and advocate of the Oriental philosophy design theory. His works of Oriental prospect and romantic charm have extensive influence and charisma. In 2009, he was involved in launching the Zhongxuanmei program. In 2011, he and Mi Shijie, a vision researcher, collaborated to establish IdeaWorks Synthesis Design Research Institute. Zijns is one of the authors for Design Belief- Power of Profession.

p.244-248

Acknowledgements

We would like to express our gratitude to all of the designers and companies for their generous contribution of images, ideas, and concepts. We are also very grateful to many other people whose names do not appear in the credits but who made specific contributions and provided support. Without them, the successful completion of this book would not be possible. Special thanks to all of the contributors for sharing their innovation and creativity with all of our readers around the world. Our editorial team includes editor Yuanyuan Shi and book designer Leo Cheung, to whom we are truly grateful.